SKETCH MANGA
A Draw-Inside Step-by-Step Sketchbook

IMPACT

CINCINNATI, OHIO
www.impact-books.com

CONTENTS

Includes tips, advice and how-to instruction on:

BASIC EQUIPMENT

The tools named here aren't absolutely necessary. As long as you have a pencil and paper, you can certainly get some drawing done. But these tools will help make the process of creating illustrations and comics easier and faster.

Mechanical Pencils
Mechanical pencils are great since you don't have to keep sharpening them, and you can switch types of pencil leads.

All You Really Need is Pencil and Paper
Don't get overwhelmed with all the available materials out there. When it comes down to it, all you really need is a pencil and paper.

WHICH PENCIL LEAD TO USE?

Harder pencil leads are classified as H, while softer leads are classified as B. The harder the lead, the lighter the mark. H leads are easier to use for drawing graphic novels. The lines are lighter and they don't smudge as much as the softer B leads.

4H

3H

H

HB

2B

Straight Edge
A triangle is a step up from a typical ruler. It allows for perfect ninety-degree angles, which are handy for making comic book panels.

Erasers
A kneaded rubber eraser eliminates the mess of eraser leavings. It gets dirty very quickly though, especially if you tend to erase a lot. If you use something like a vinyl eraser, use a cheap, wide, dry paintbrush to brush away the eraser leavings. It won't smudge your art like using your hand can.

Paper
Try a variety of paper types like this workbook to see which works for you.

4

Get a few different pencils with harder and softer leads. Try them out on this page to see what you like and what each one can do.

BASIC EQUIPMENT

Gel Pens

Gel pens come in various nib sizes. The ink flows smoothly and doesn't clot, but the drying time isn't very fast. It's great for drawing the straight, crisp edges of buildings.

Felt-Tipped Pens

Felt-tipped pens also have different-sized nibs and are available at most art and craft stores. They dry quickly and the ink rarely, if ever, smudges.

Permanent Markers

Permanent markers are also easily found in stores. Just remember to use them in a room with good air circulation.

Brushpens can create lines of varying width, depending on how much pressure you apply while inking.

A brushpen with a bigger brush is useful for inking and filling in large areas.

Brushpens

A brushpen is exactly what it sounds like, an inking pen with a brush tip. Different brands have different brushes, and prices vary.

Most brushpens are refillable—which is good news for your wallet.

Get a few different types of pens and try them out here. See what each one can do and which you prefer.

BASIC HEAD CONSTRUCTION

Drawing the manga head is all about knowing how to fit basic forms onto a simple circle and triangle shape. Start by comparing the standard academic style of drawing with the manga style. Academic drawing is the kind of formal drawing taught in art schools, the kind used to draw realistic-looking people. It comes in handy when drawing manga, too!

1 The Realistic Head Shape
OK, you're looking at it. A simple oval shape is all you need as the basis for the standard human head. If you have trouble getting a good oval, you can use a template to trace it.

CAN YOU SPOT THE DIFFERENCES?

More important than the differences are the similarities. The basic tools used to construct both types of heads are virtually the same!

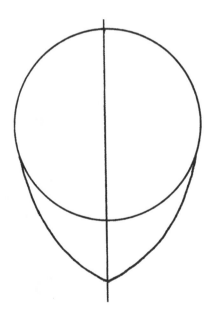

1 The Shoujo Head
The term "shoujo" means "comics for girls" in Japan. Draw a far more exaggerated oval shape. Draw it as a circle and attach a slightly curved triangle to its lower third. The point of the triangle should be in the center.

 Learn more about manga at http://ImpactSketchbooks.Impact-Books.com

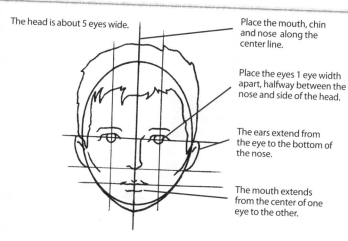

The head is about 5 eyes wide.

Place the mouth, chin and nose along the center line.

Place the eyes 1 eye width apart, halfway between the nose and side of the head.

The ears extend from the eye to the bottom of the nose.

The mouth extends from the center of one eye to the other.

2 Begin Details

Taper the oval and begin to add features. Give some shape to the chin. Place the features.

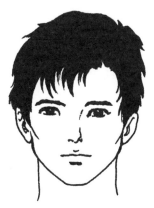

3 The Realistic Finish

To finish off your "realistic" head, carve out a bit of the oval to get cheekbones and a jaw. Refine the features, and this is a pretty attractive guy!

The head is only about 3 eyes wide.

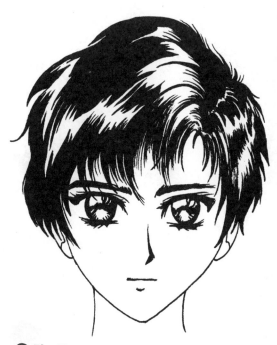

Place the eyes slightly below the center of the head.

The distance from nose to chin is shorter.

Draw the mouth very small. It extends to the inside corner of the eye.

2 Begin Details

Using a circle instead of an oval makes for an incredibly prominent cranium. Those big eyes have to fit in there somehow! The manga cranium is almost always quite large. And the big eyes and small chin give the face a more delicate appearance.

3 The Shoujo Finish

See the big difference a few details make? Underneath all this hair and those big eyes is very simple construction that isn't much different than the more realistic head you have drawn. The shoujo cranium is larger, the chin is more pointed, the jawline is less square and the eyes are easily four times as large as a normal human eye. You get big results from these little differences! Take the time to draw these basic forms over and over. Get used to building the head from these simple steps.

OTHER STRUCTURAL CONSIDERATIONS

Exaggeration

In manga, facial features and expressions tend to be exaggerated, so the rules of proportion shift slightly to accommodate style.

When you make an eye wider, leave roughly twice as much space between both eyes as there is between the eye and the edge of the face. For making the eyes taller, take space away from the cheeks; the upper lid stays lined up with the horizontal guideline of the face. This makes the face look like it's still in proportion, even with the large eyes.

The large eyes used in manga also affect the profile view of the face. The brow bone is stretched out and the nose bridge gets shorter.

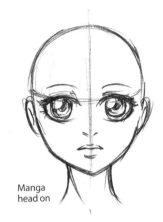

Manga
head on

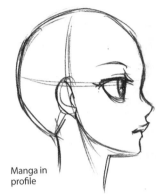

Manga in
profile

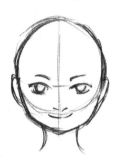

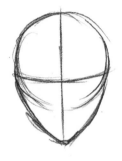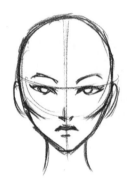

Anything Goes!

Now that you know the basic facial structure, you can create unique features. Draw a stronger jaw, sharp eyes, thin lips or round cheeks. The possibilities are endless.

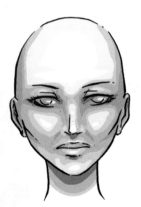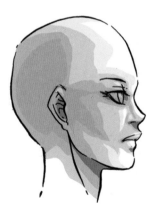

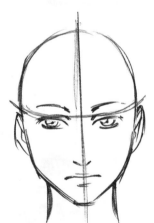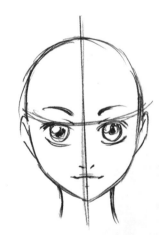

Lighting

The varying shades of blue show the shadows and highlights as a light source washes over the face. If the light intensifies, the lighter colored areas will be washed out and the shadowed areas will recede.

Boy vs. Girl Faces

With a generic male face (left), the jaw is more defined and the chin is wider and flatter. The face is slightly longer than a female face (right), with a longer nose. A younger male can have a softer facial structure like a female character, though. Details like thinner lips and shortening or leaving off the eyelashes will make him look more like a boy.

16

Using what you've learned on previous pages, sketch a basic manga head, or more than one. Think about unique features you can give your characters.

SMALL CHANGES, BIG DIFFERENCES

So now you know the secret of the circle and triangle. These manga heads show how just a few simple changes in the circle/triangle combination make for big differences in the shoujo head. These shapes are usually used for adult men and women or older teens.

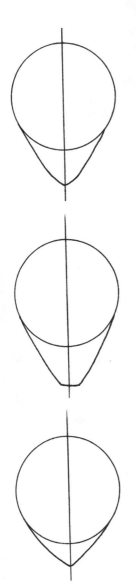

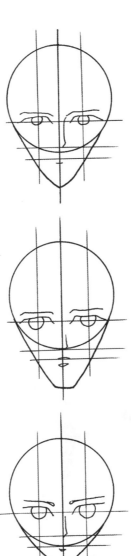

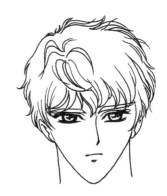

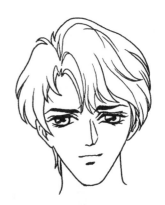

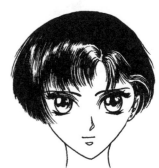

1 Use your template to draw three circles. If you're feeling bold, draw them freehand. Draw a line directly through the center of each circle. Extend two curved lines that meet at the point below the center. There's a lot of variety in chin shapes.

2 Here's where you can have some fun! Copy these sketches or try some of your own. Move the features up and down, widen the eyes and play with the shape of the mouth. Notice how each head has different eye shapes. Some of the eyes are higher on the face than others.

3 All these faces are in different shoujo styles, but all use the same basic building blocks. The length of the chin and width of the eyes completely change the character of the face, yet the shapes underneath the sketches are incredibly simple to draw.

This is why it's important to practice drawing the basic structure of the head. Like the famous Japanese tea ceremony, it looks simple, but simple things are important!

Have some fun trying different things with your manga faces!

TRY $OME MORE!

These shoujo head shapes are more often used for girls and boys
or very young children.

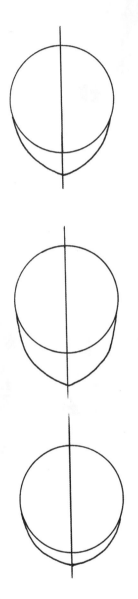

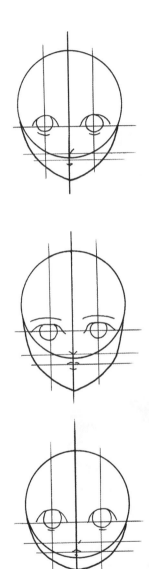

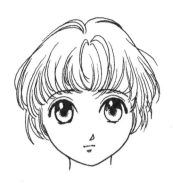

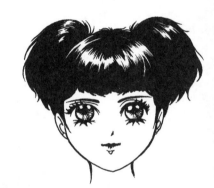

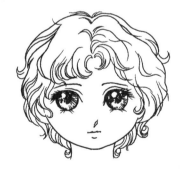

1 For younger manga characters, draw the chins much shorter and rounder. This makes the jawline very curved and full.

2 Children's eyes are larger in proportion to their heads and their eyes are set lower in the head. Place them at the point where the jawline triangle meets the head circle. Since the jaw is shorter, the distance between the mouth and chin is also shorter. Make sure their faces remain more rounded.

3 These examples show, yet again, what a huge difference the basic head structure makes in the shoujo head. Your basic building blocks won't change, but how you use them changes everything. Underneath every complex drawing is a simple structure.

Try some younger manga characters.

WINDOWS TO THE SOUL: MANGA EYES

Nothing captures the shoujo manga look like big, luminous eyes. Large eyes are infinitely expressive and drawing them well will go a long way toward making your art look appealing. Eyes are very easy to draw in a variety of shapes and styles.

To draw the manga eye at its best, we need to take a moment to study construction of the real human eye.

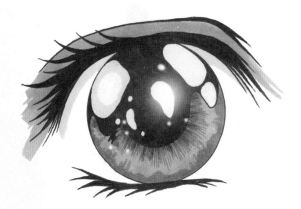
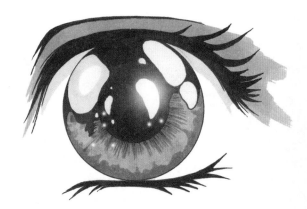

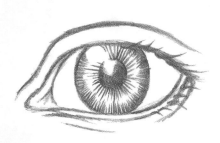
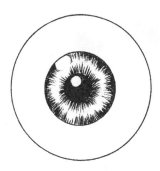
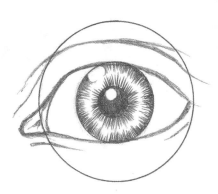

The Human Eye

The eye's almond shape is suggested by the muscles and skin around a large orb. This orb rests way back inside your head. You only see a small portion of the eyeball.

The Eyeball Is Huge

As you can see, the eye is a lot bigger than it seems! Yet the pupil and iris are much smaller than the whole of the orb. Remember that the skin surrounds the round surface. Keep your lines rounded.

What Eyelids Do

The eyelids shape and cradle the surface of the eye, giving the eye its characteristic almond look.

 Learn more about manga at http://ImpactSketchbooks.Impact-Books.com

THE SHOUJO EYE

The shoujo manga eye is constructed just like a real eye, only it is much simpler to draw.

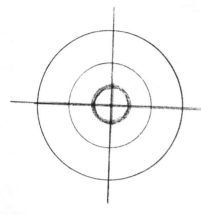 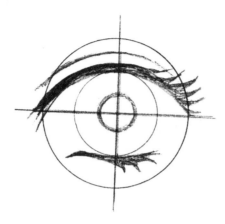 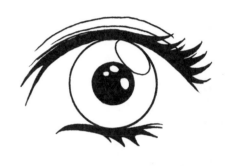

1 Draw three circles, as if you are drawing a bull's-eye target. The large circle is the orb of the eye; the smaller, the iris; and the smallest, the pupil.

2 Here's the big difference between the manga eye and the real eye. In the manga eye, the lids are almost never drawn to meet. Simply draw two sweeping sets of eyelashes. Make them as thick or thin as you like. Thinner eyelashes are usually drawn for men.

3 Ink in your drawing, add a couple of highlights, and you are finished. This is the simplest kind of manga eye to draw.

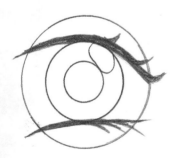

To get completely different looks, use the bull's-eye circle you drew as your basis for each kind of eye. Change the eyelid line. See how simple it is to draw very different types of eyes simply by moving around the lid.

CREATE PAGES OF EYES!

Beautiful manga eyes come in many shapes and colors. Experiment with different types. Give the eyes blue eyelashes or green lids. There is no one way to draw the shoujo eye. You can come up with your own unique styles.

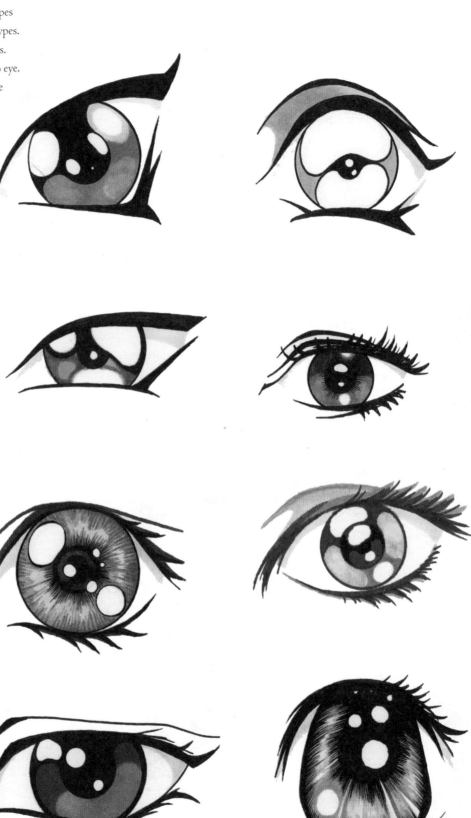

Try lots of different shapes of manga eyes. Try coloring them in if you like.

SIMPLE TRICKS FOR SPECIAL EYES

The Starlight Eye

The big difference here is that there is no pupil or iris or white of the eye.

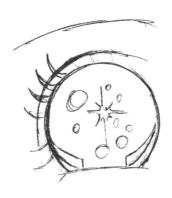

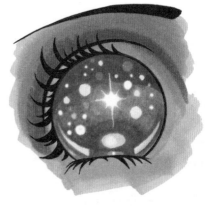

1 Draw a circle, just like you would for other eyes.

2 The whole top portion of the circle is your eyelid! Sketch eyelashes along that line. Sketch in circles and stars throughout the orb.

3 Trace your drawing in ink, or color it in. Colored, you can really see the incredible effect of this eye! Use three or more shades of blue for a dreamy effect. This is a great looking eye!

The Starburst Eye

Imagine this eye on a woodland elf! Use the same big circle base that you used for the Starlight Eye.

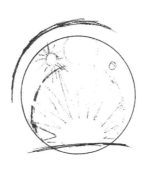

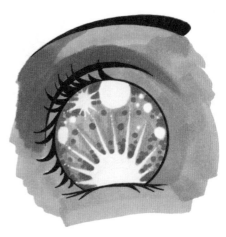

1 Make two circle sketches within the eye shape and draw radiating lines along the circles. Add lots of stars and highlights, too.

2 Color in your eye with moss green tones. Color other eyes in blues or golds for really interesting looks. This is definitely a shoujo style that needs to make a comeback. It's gorgeous!

Use your imagination to either try the special eyes here, or come up with your own.

CHANGE THE VIEW

By simply changing the angles of your basic facial guidelines, you can draw the face from many different perspectives.

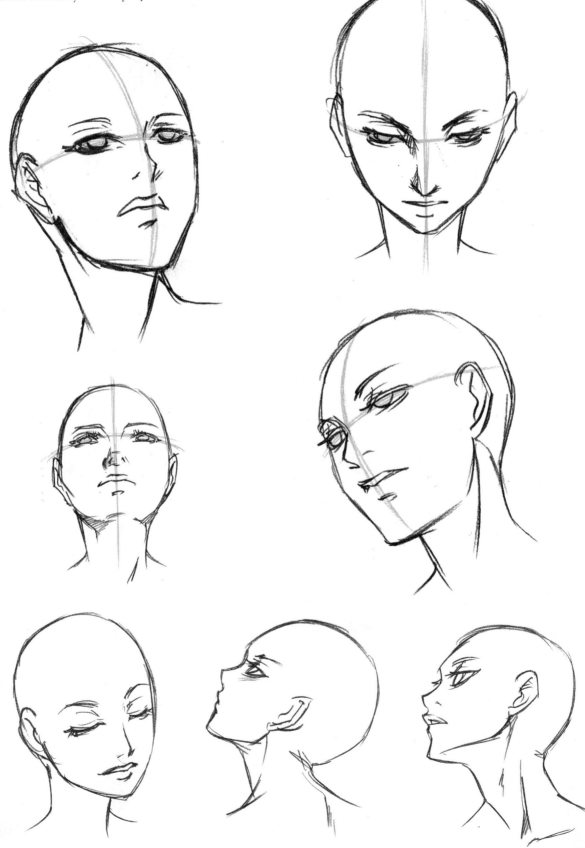

Now that you've tried lots of faces straight on, try sketching some other angles.

SHORT HAIR

Short hair is really versatile and fun to draw. It can be really short and close to the scalp, slightly longer and spiky, smooth and orderly, styled or in complete disarray.

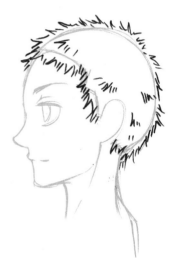

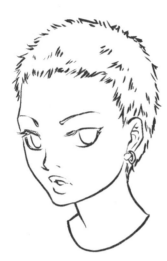

Close-Cropped Hair
Use short, abrupt strokes to give the effect of close-cropped hair.

Messy Hair
Create bands of white that overlap each other in different lengths and directions.

To create the look of messy dark hair, make the bands of white very minimal. Break them up often with a lot of black to give the illusion of a lot of strands of hair that stand out rather than being sleek and flat.

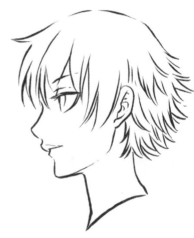

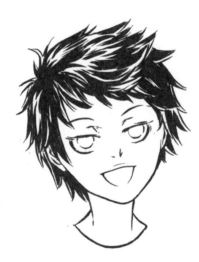

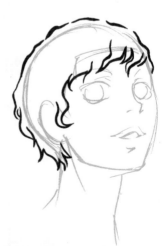

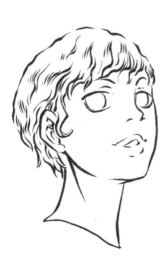

Simple Wavy Hair
Draw the outline of the hair. A couple of these line groups will give the effect of soft waves in the hair.

Draw a longer wave and smaller waves emanating from it, following its shape.

Have fun sketching different short styles!

LONG HAIR

Long hair isn't all completely even, and doesn't flow neatly down a person's back. Long hair drapes and falls over the shoulders, and if hair has a bit more volume or wave, it makes its own shape as it flows.

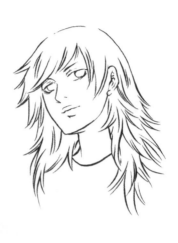 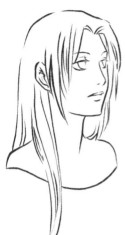 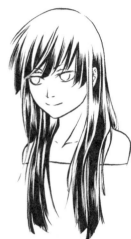 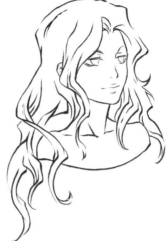

Draw a Simple Braid

1 Create the Basic Shape
Start with a wide base that tapers down to the end of the braid. Draw a bunch of V shapes, but let the lines on one side of the braid overlap the other lines.

2 Develop the Shape
Draw the lines all the way to the base of the braid. The space between the lines decreases as you get closer to the end.

3 Refine the Shape
Round out the outside lines. Each space is a mass of hair getting tucked into the facing group.

4 Develop the Details
The areas where the hair weaves in the middle get more shadow. The strands of the hair follow the direction of each braid section.

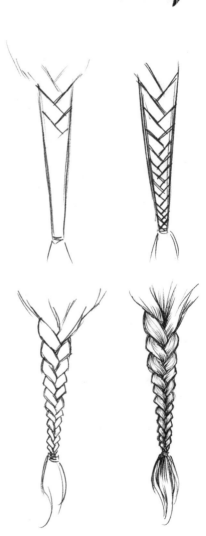 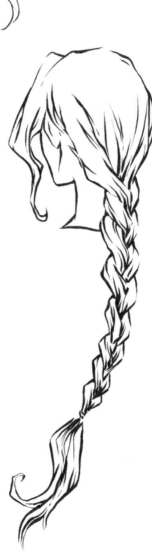

Now have fun sketching different long styles!

YOUNGER GIRL

Now use another head shape to draw a shoujo girl. Younger characters generally have shorter or more rounded triangles for their chins.

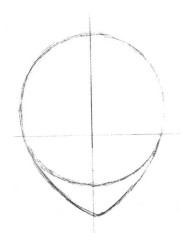

1 *Draw the circle with a shorter triangle.*

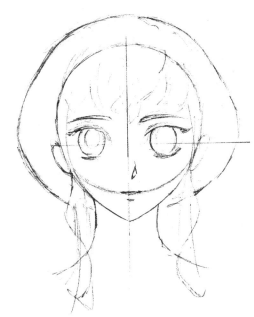

2 *Add the guidelines and block in the hair. Make the eyes really big. Give her one of those cute hairdos! Add tendrils of hair hanging down about the ears. Remember to keep your sketch light and simple at this stage.*

5 *Go with another wild manga color for hair: in this case, pink. Draw in the dark-colored areas of the hair and leave large areas blank for highlights. A cool gray is the perfect tone for shadows on the face. Draw in the shadow under the chin, add shadows below each tendril of hair and around the edge of the face and eyes.*

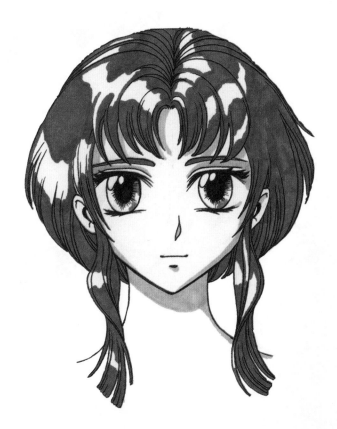

3 Clean up your drawing. Erase all lines you won't use in the final work. Use a light hand when drawing at these early stages.

4 Inking isn't just about tracing. A lot of grace and style goes into the pen lines. Keep your line delicate. Add tiny lines radiating from the pupil to make them look even prettier. Most manga are published in black and white. It is crucial to learn to draw in ink.

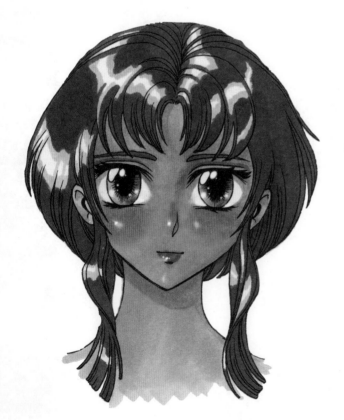

6 Use a slightly pinker skin tone to complement the hair. Create highlights on the cheeks, nose and chin either by leaving those areas blank or drawing them in with a white colored pencil or white paint. Add a few more highlights to the eyes. Use more than one color for eyes to make them really luminous.

DRAWING BASICS: HUMAN ANATOMY

Human bodies come in many shapes and sizes, but the following proportional details apply to all:

- The elbows align at about the waist.
- The wrists align with the groin area.
- The hips mark the halfway point on the figure.

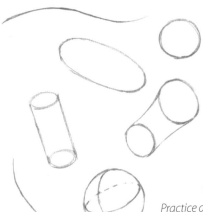

Basic Building Blocks

Practice drawing basic shapes and sweeping lines. Sketch lightly and quickly to create flowing and organic-looking lines. Once you have circles and ovals down, try connecting shapes to create 3-D forms.

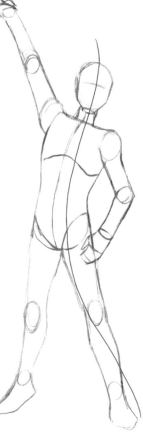

Ready, Set, Action!

Artists use a "line of action," an imaginary line that is drawn prior to the figure, to establish the main direction of action. It's helpful for inspiring strong, dynamic poses. The line of action sometimes follows the character's spine, but not always. Think of it more as a force guiding the action of the character, rather than part of the figure.

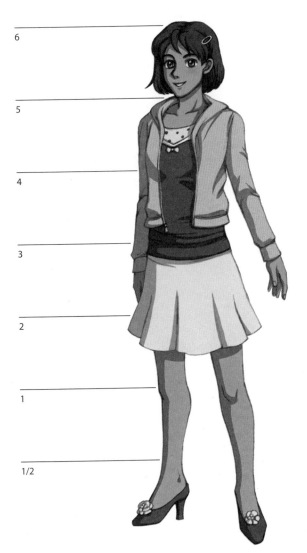

6

5

4

3

2

1

1/2

Staying in Proportion

In art, body proportions are measured using a head to body ratio. In general, adults are about 7 to 7½ heads (8 heads if they are especially tall), teens are 6 to 6½ heads, children are 4 to 5, and babies are 3 heads tall. It's worth noting that the torso on the adult figure is about 3 heads tall. Keep in mind that these are just averages.

Practice sketching basic lines, shapes and proportions.

THE DIFFERENCE BETWEEN GUYS AND GIRLS

A real life figure might be seven heads tall or less, but a slightly exaggerated comic book style often has longer limbs.

These figures are approximately eight heads tall. The female figure is half a head shorter than the male, yet her height is still about eight times the length of her head.

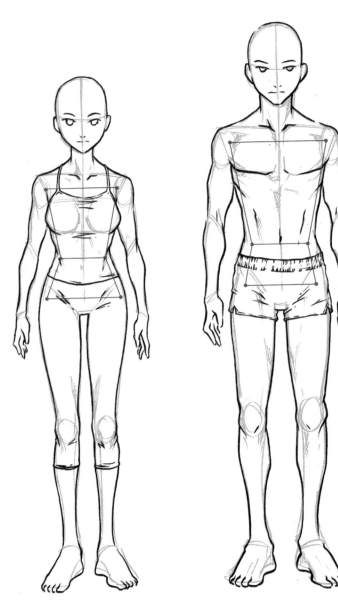

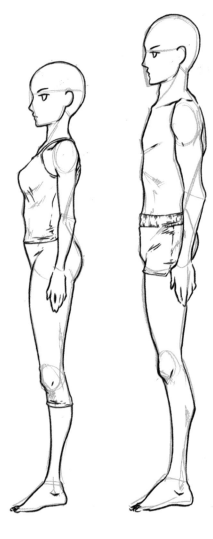

Start at the Top and Work Your Way Down

A guy's neck is thicker and his shoulders are broader than a girl's. Looking at the red lines and dots, you can see the difference in the length of the upper body and the width of the hips.

The arms on both figures are about four heads long; the elbow is almost at or slightly above the waistline, and the wrists are even with the bottom of the hips. The legs on both figures are longer than an average real-life person, but longer legs and arms are pretty common in most comic books.

Profiles Are Trickier

The halves of the body aren't identical. The torso is not a flat board that goes straight down. There are the collarbones in front, and the Adam's apple on the neck of the male figure. Then there is the difference in chest and hips. The back curves out at the shoulder blades and curves inward at the top of the gluteus. There is a slight S-shaped curve from the top of the leg to the ankles.

Try sketching a girl versus a guy, noting the differences.

VICTORIAN GENTLEMAN

Bishounen (a term used in Japan meaning "pretty boys") are often better classified as bad boys rather than tough guys. They are usually the mysterious helpers in shoujo comics, unattainable love interests who constantly distract and occupy the thoughts of the heroine. They often have a wild and dangerous nature that makes them even more mysterious and attractive.

Bishounen characters are usually long and lanky and have wild, uncontrollable hair. Dressing them up in tuxedos or formal wear reinforces the "beautiful boy" stereotype.

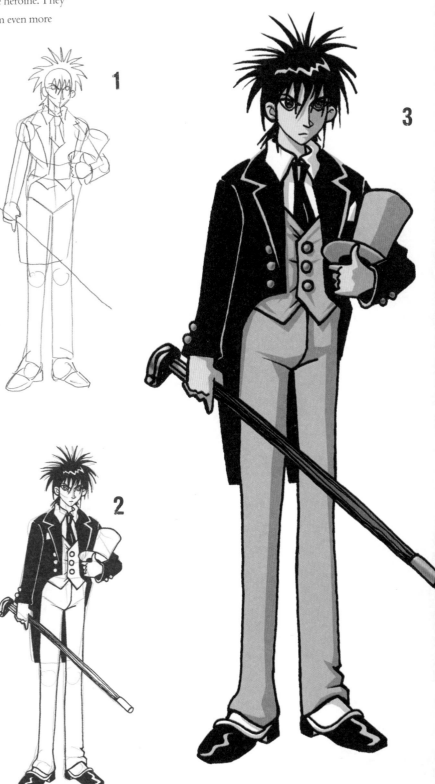

1 *Much of what will be drawn in the end is sketched out here. Try to break down every complicated object to its basic shapes and forms. The fact that his top hat is a cylinder is very obvious in this sketch. Notice that he is slightly off balance, leaning forward with almost all his weight on his left leg. Putting a character off balance creates tension and movement.*

2 *Use references to get the specifics of his tuxedo right. Leave white lines for the details on black (his coat buttons, lapel and arm lines and the highlights on his shiny shoes). Carefully observe folds and creases in the clothing to help show tension and 3-D form—for example, where his buttons tug at his vest.*

3 *His tuxedo is a conservative color, but his red eyes pierce out from behind his tangled mess of hair. Odd-colored eyes could reveal an alien or magical aspect of the character. He might be a vampire, a type of goblin, an alien or even a robot. Or, the eyes could mean nothing at all, but simply make the character appear more interesting or whimsical.*

Try this bad boy, or sketch your own!

HIPSTER STUDENT

The details of this school uniform are not accurate for modern Japan, but it would work in a story of another place and another time. Bishounen characters like this one are often filled with angst and brood over even the smallest decision.

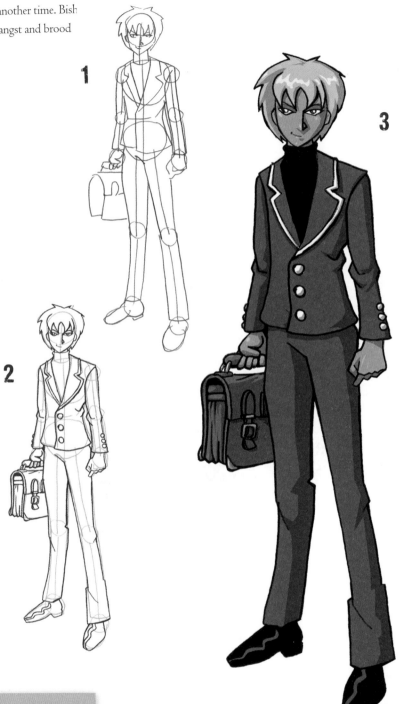

1 *Observe costume details such as the cut of the jacket, the curves of the pant legs and the jacket sleeves. Wrap the clothes around the basic body structure.*

2 *The clothing folds and creases on his lower legs, elbows and waist give the figure a strong sense of 3-D form. Use your references to draw details like the jacket lapels and the briefcase. He's turned slightly to the side, so the shoulder and lapel farthest from us will look narrower, and we'll see only a hint of the buttons on that side.*

3 *Keep the color choices simple. Too many colors can make a drawing difficult to follow. The most striking thing about this character is his blue hair, which symbolizes his exotic nature.*

MALE OR FEMALE?

In manga you'll find characters that appear somewhat androgynous—having male and female characteristics. This might be a nod to the historical tradition of Takarazuka theater, where female actors played male roles. This tradition lived on in the comics originally based on Takarazuka stories.

Now try this guy, or another of your own!

GIRL NEXT DOOR

There's nothing wrong with being "the girl next door," or with having a resumé as long as your arm. A big believer in hard work and experiencing life just for the sake of it, Trey McKinney has taken every sort of seasonal position available—Christmas elf, renaissance festival performer, cashier on Black Friday, and even some volunteer work now and then. She doesn't need the money, but understands the benefits of doing things for herself. While her eternally positive attitude has left her social skills a little lacking, and she is often oblivious to people around her, whatever time Trey has left over from work is always available to be eaten by friends and potential significant others, even if she can't really tell the difference.

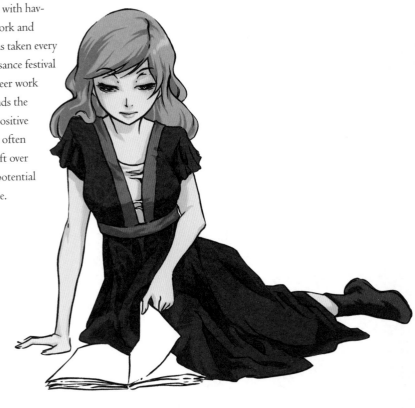

1 Strike a Pose
She's very calm, proper and ladylike. Trey doesn't move around too much, either.

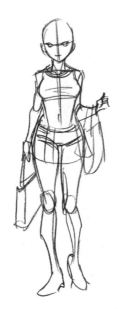

2 Fill It In
Draw the body and facial structure. Trey has an average body type. The pose isn't anything remarkable, but her right hip juts out a bit since her weight is on that leg. To give the picture a little more interest, bend an arm up, and add a shopping bag.

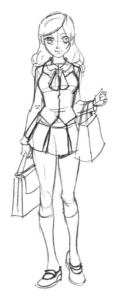

3 Rough In the Details
Add detail to the facial features. For the most part, Trey usually has a small smile on her face, and the set of her eyes is open and friendly. Her hair is always neat, and although it's wavy, the strands are always in place.

4 Clean-Up and Inks

Keep the lines smooth and draw a minimum of fabric creases. Add just a few where her limbs bend, where the vest stretches at her waist and under the chest and the creases at the seam of the skirt.

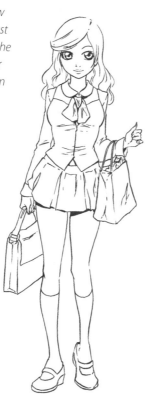

5 Color

Trey wears a large array of colors from dark tones to pastels, but her outfits always match.

hair colors

eye colors

skin and lip colors

clothing colors

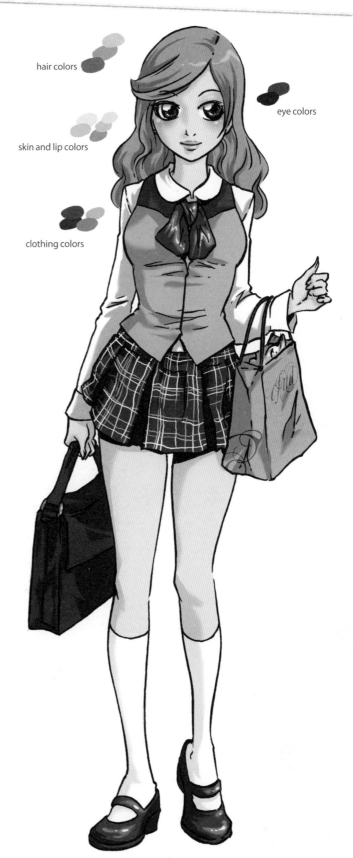

Other Looks for Trey

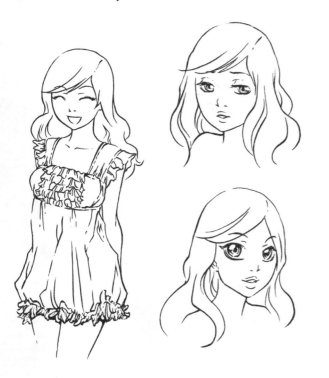

TWO FRIENDS

Though not close enough that they are seen hanging out much, Teddy and Odessa's mutually extroverted and generous attitudes mean they get along pretty well. Odessa is always alert for the possibility of someone trying to get her attention as she passes, so when she heard Teddy call her name, Odessa slowed her walk until the blond girl caught up. The girls are glad to see each other; Odessa appreciates Teddy's ingenuity in making sure something interesting is always going on, and Teddy just appreciates everything.

Teddy and Odessa often cross each other's paths. Maybe at the same party, or maybe they were just shopping at the same store and decided to hang out.

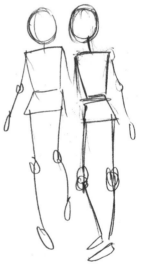

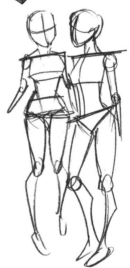

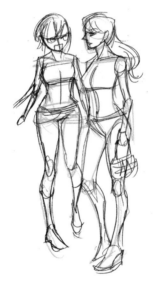

1 Strike a Pose
Teddy is on the left and Odessa on the right. Their stances reflect their different personalities; Odessa stands straight but relaxed, while Teddy's extended arms show a higher energy.

2 Fill It In
Establish the angles of their faces and rough in the bodies. Teddy is slightly behind Odessa and is walking up to her, so her feet are on a higher plane. Their heads are almost level, though, since Teddy is the shorter of the two. Meanwhile, we want to be able to see Odessa's face, so she doesn't turn completely to face Teddy, and instead lets the other girl come up to her side.

3 Rough In the Details
Add the facial features and hair, and sketch in the clothes. Since Teddy is heading toward Odessa, her hair shows a bit of that movement. The rough pencils from step 2 are shown here in blue to make it easier to see the additional details of expressions, anatomy and the rough details of the clothes.

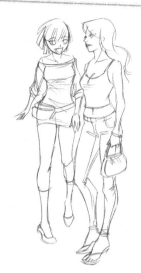

Think about how your characters are dressed and what their bodies are doing. Teddy's arms are set opposite her feet, another hint that she's walking. And don't forget the accessories; if the girls are dressed for walking around town, they'll need somewhere to keep the necessities.

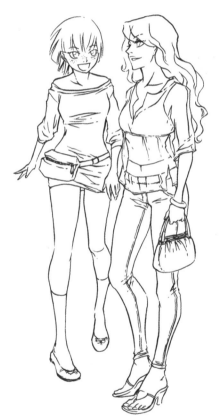

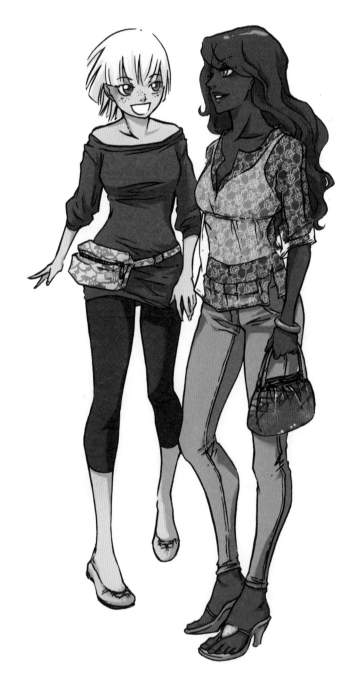

4 Clean-Up and Inks

Add more detail to the clothes, faces and the overall image. Teddy's shirt is fitted and stretches under the chest, but the sleeves are baggy. The cloth also stretches across her hips because of the walking motion and being caught under the hip bag. Odessa's clothes have some wrinkles as she bends her limbs, but she generally has fewer lines on her clothes.

5 Color

Use the individual character's palettes to choose the colors.

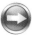 Learn more about manga at http://ImpactSketchbooks.Impact-Books.com

ANTHROPOMORPHIC CHARACTER (NEKO)

Anthropomorphism means giving human characteristics to inanimate objects and animals. This, of course, leaves open a wide range of possibilities.

One common anthropomorphic character merges a human being with a catlike creature. In fact, the Japanese word for cat, *neko*, also is used as a name for such characters.

Stats

Eyes—She's usually meant to be cute; large eyes come standard.

Nose—It can be more human, but more often it resembles a cat's.

Ears—The position of the ears also can vary. Sometimes they come out from the usual place, but typically they are mounted higher up on the skull.

Body—The body usually takes a human form, but with the addition of a tail. Think of the bones in the tail as a graceful extension of the spine. It's fun to try out different animal patterns when coloring the skin. This is a creature of pure fantasy. Feel free to experiment.

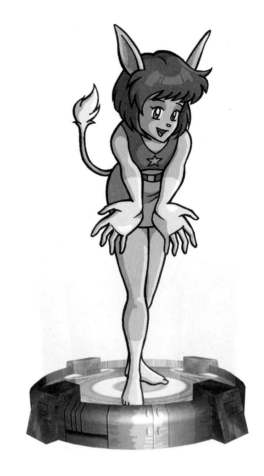

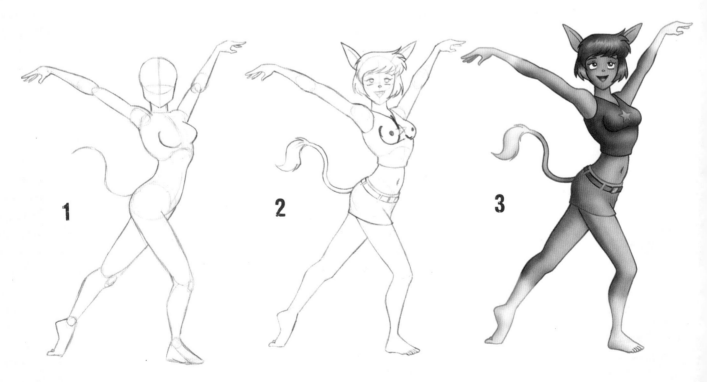

1 **2** **3**

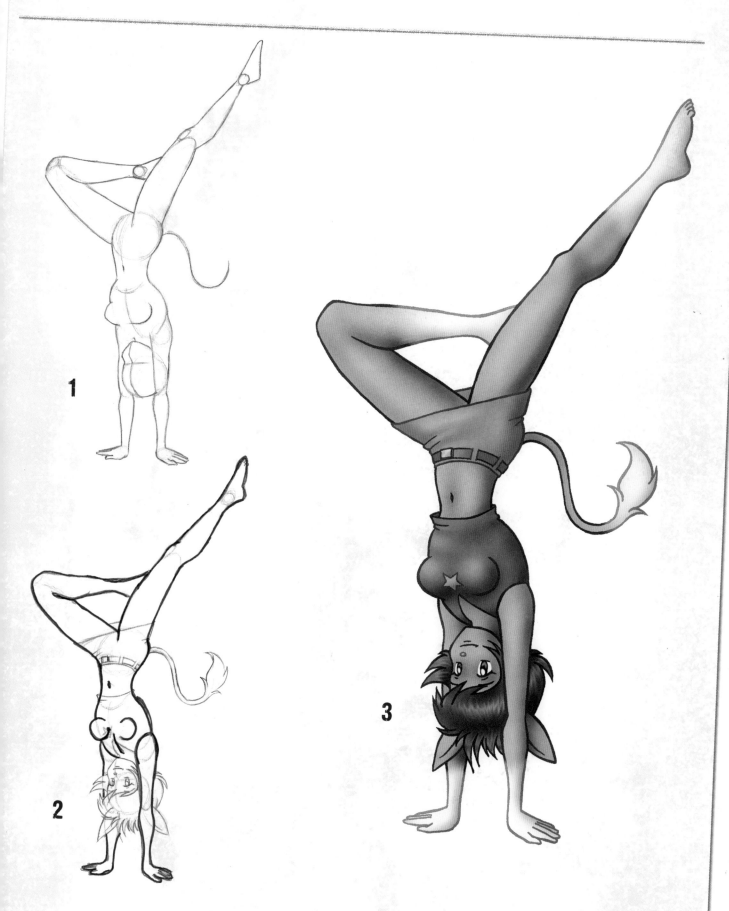

1

2

3

ANTHROPOMORPHIC FACE

The domestic cat comes in many types and colors, but the key features that will help you transform a human face into an anthropomorphized feline face are the cat's glowing eyes, small ball-like muzzle and pointy ears. Emphasize these striking details as you draw your cat girl's face.

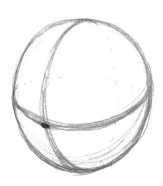

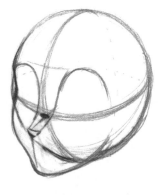

EYE TIP

Cat eyes are large and built for nocturnal hunting. Domestic cats have eyes that form into tight slits in bright light, but open wide and round in dim light. Large cats' pupils are always round. Since your character is only part cat, you can use these eyes or standard human eyes, depending on which animal aspects you want to express in your anthros.

1 Start With a Circle
Draw a circle. Next, draw a vertical guideline across the curvature of the circle to bisect the head. Then, draw a horizontal guideline across the face. The crosshairs show the direction the face is aimed.

2 Form the Muzzle
Draw a small line out from the crosshairs, then draw the cat's triangular nose at the end of this line. Draw a guideline down from the bottom of the nose and place the chin. Build the brow line by pulling a pair of curved lines from the sides of the nose back into the face.

3 Sketch the Ears, Eyes and Mouth
Draw the eyes along the horizontal guideline. Make sure they are centered under the brow's arches. Pull down a pair of U-shaped lines from the base of the nose to create the mouth. Then, draw the cat's large triangular ears from the upper middle portion of the head. It helps to draw a guideline from the tip of the ears to align them.

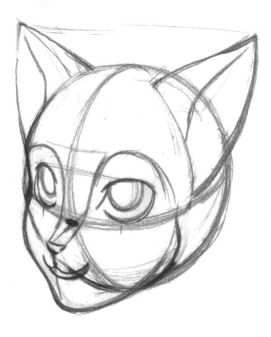

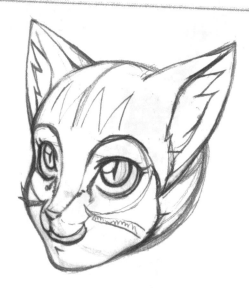

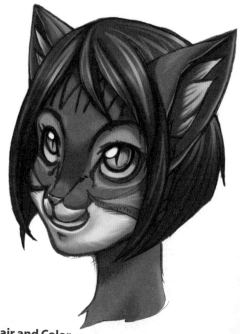

4 **Add Fur Patterns and Details**
Erase the guidelines and start drawing the facial details. Darken the lines around the eyes and mouth to help define those important areas. Next, draw in the fur patterns if desired. Since patterns can be complicated, use a cat photo for reference, or, if you prefer, just make up our own unique pattern. Magical kitty!

5 **Add Hair and Color**
Give your character even more style by sketching in some hair. Remember to structure the hair around the ears, otherwise it'll make the ears look two-dimensional. Finally, color your character. Use photos or live cat models for reference. Stick with standard colors, or be creative.

Drawing Feline Eyes

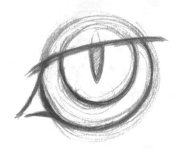

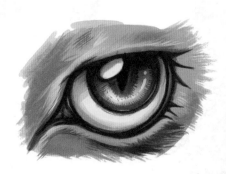

1 **Create the Basic Eye Shape**
Start with a circle. Draw a horizontal line across the circle for the eyelid. On the side of the eye closest to the nose, draw a line diagonally away from the circle to create the inner corner of the eyelid. Darken the portion of the circle below the eyelid to define the visible eyeball.

2 **Draw the Iris and Pupil**
Join the inner corner of the eyelid to the eyeball with a line. Draw a circle for the iris. Normally a cat's iris fills the entire eye socket, but since this an anthro cat, you can incorporate human characteristics by showing some white around the iris. Draw the pupil (slit or round) in the center of the iris.

3 **Add Detail and Color**
Erase construction lines and add details around the eye, even eyelashes if you like. Then add color. Cats typically have blue, green or gold eyes. Cat eyes are also very reflective, so let them shine!

FULL BODY ANTHROPOMORPHIC

As you draw your cat girl, keep in mind the sleek looks, compactness and amazing abilities of a springy house cat, and adjust the basic human anatomy accordingly. Since this cat girl is still an adolescent (not a kitten, but not quite a cat), she's about 6 heads tall instead of the more adult 7 to 8 heads.

1 Sketch the Basic Body Shape
Start with a curvaceous line of action to give the cat girl a lot of spring. Next, draw the circle for the character's head with accompanying crosshairs. Roughly following the line of action down from the head, draw in the character's neck and three torso segments. Draw a guideline down the middle of the body (it's helpful for symmetry).

2 Draw the Limbs and Tail
Draw the tail at the base of the spine. Then draw the limbs out of the circular joints on the chest and pelvis. Because the cat girl is slightly turned, the joints on her left side are hidden from view. To approximate the position of these hidden joints, draw guidelines through the body. If it helps you to visualize, draw the limb segments that the body overlaps, and clean it up later.

CLOTHING TIP

Unless you want your character's clothes to be "fur tight," draw them hanging slightly off the body. Don't forget to add some lines to indicate wrinkles and folds, especially around joints, where fabric tends to bunch.

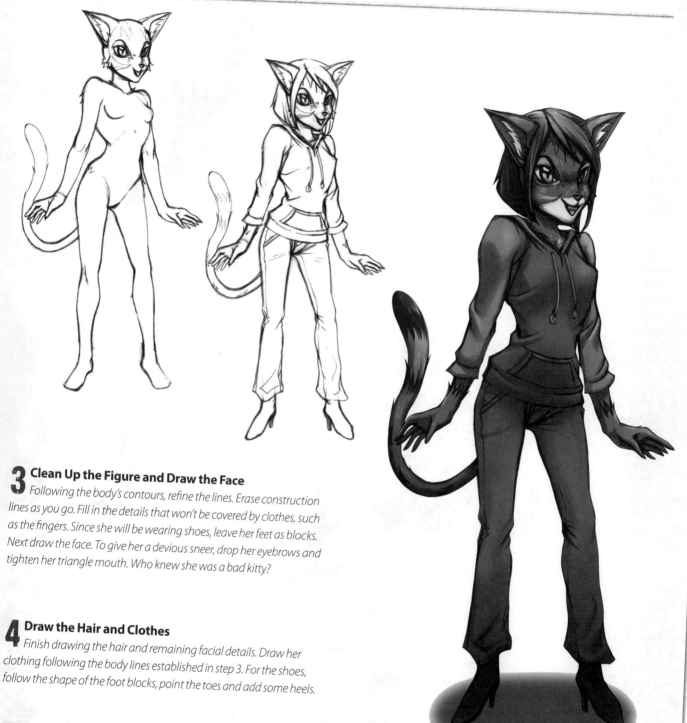

3 Clean Up the Figure and Draw the Face
Following the body's contours, refine the lines. Erase construction lines as you go. Fill in the details that won't be covered by clothes, such as the fingers. Since she will be wearing shoes, leave her feet as blocks. Next draw the face. To give her a devious sneer, drop her eyebrows and tighten her triangle mouth. Who knew she was a bad kitty?

4 Draw the Hair and Clothes
Finish drawing the hair and remaining facial details. Draw her clothing following the body lines established in step 3. For the shoes, follow the shape of the foot blocks, point the toes and add some heels.

5 Color the Kitty
Since you're creating a furry character, consider fur patterns and colors as well as flesh. This cat's simple tabby pattern consists of three main colors: orange-brown fur, a bit of white around the face and some dark stripes scattered across her pelt.

 Learn more about manga at http://ImpactSketchbooks.Impact-Books.com

Other fine IMPACT Books are available from your favorite bookstore, art supply store or online supplier. Visit our website at www.fwmedia.com.

15 14 13 12 11 5 4 3 2 1

DISTRIBUTED IN CANADA BY FRASER DIRECT
100 Armstrong Avenue
Georgetown, ON, Canada L7G 5S4
Tel: (905) 877-4411

DISTRIBUTED IN THE U.K. AND EUROPE BY
F&W MEDIA INTERNATIONAL, LTD
Brunel House, Forde Close, Newton Abbot, TQ12 4PU, UK
Tel: (+44) 1626 323200, Fax: (+44) 1626 323319
Email: enquiries@fwmedia.com

DISTRIBUTED IN AUSTRALIA BY CAPRICORN LINK
P.O. Box 704, S. Windsor NSW, 2756 Australia
Tel: (02) 4577-3555

Edited by Pamela Wissman and Kathy Kipp
Cover designed by Laura Spencer
Interior designed by Wendy Dunning
Production coordinated by Mark Griffin

Special thanks to the following artists whose work appears in this book:
Irene Flores
Colleen Doran
Lindsay Cibos and Jared Hodges
David Okum
Mario Galea

The artwork in this book originally appeared in previously published IMPACT Books. Page numbers shown below refer to the pages in the original books.

Shojo Fashion Manga Art School © 2009 by Irene Flores.
Pages 8-9, 10-11, 18, 38, 39, 52, 54, 98-99, 108-109, 120-121.

Draw Furries © 2009 by Lindsay Cibos and Jared Hodges.
Pages 10, 14-15, 16-17.

Girl to Grrrl Manga © 2006 by Colleen Doran.
Pages 16-17, 18-19, 20-21, 25, 26, 42-43.

Discover Manga Drawing © 2006 by Mario Galea.
Pages 88-89.

Manga Madness © 2004 by David Okum.
Pages 76-77.

METRIC CONVERSION CHART

To convert	to	multiply by
Inches	Centimeters	2.54
Centimeters	Inches	0.4
Feet	Centimeters	30.5
Centimeters	Feet	0.03
Yards	Meters	0.9
Meters	Yards	1.1

IDEAS. INSTRUCTION. INSPIRATION.

These and other fine IMPACT products are available at your local art & craft retailer, bookstore or online supplier or visit our website at www.impact-books.com.

Get Organized! **Master Your Studio Space**

the
Artist's
magazine

12-Hue Color Wheel

Painting Children
Tips from 4 Experts

Compelling Abstracts
7 Design Strategies

Underpainting Techniques
for Colored Pencil and Pastel

January/February 2011
www.artistsmagazine.com

Receive a FREE downloadable issue of The Artist's Magazine when you sign up for our free newsletter at www.artistsnetwork.com/Newsletter_Thanks.

Shojo Fashion Manga Art School • paperback • 144 pages

Draw Furries • paperback • 128 pages

Manga Madness • paperback • 128 pages

Girl to Grrrl Manga • paperback • 128 pages

Discover Manga Drawing • paperback • 96 pages

IMPACT-BOOKS.COM

- Connect with other artists
- Get the latest in comic, fantasy, and sci-fi art
- Special deals on your favorite artists